DOUBLE VISION: STAN DOUGLAS AND DOUGLAS GORDON

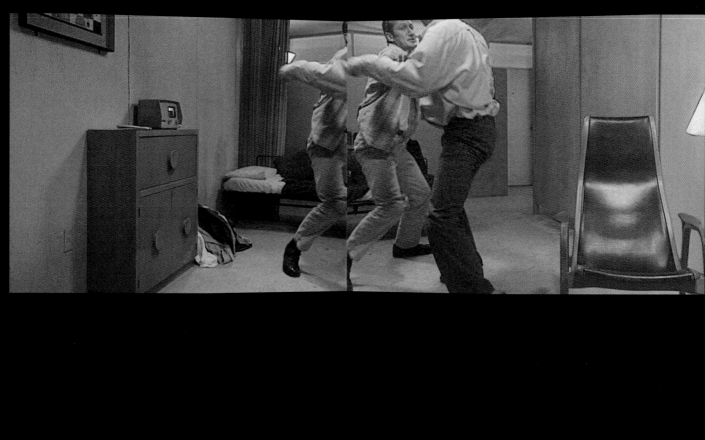

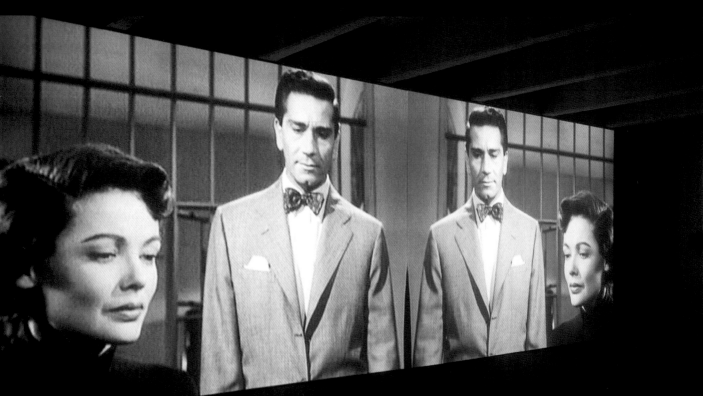

DOUBLE VISION: STAN DOUGLAS AND DOUGLAS GORDON

Dia Center for the Arts

Double Vision: Stan Douglas and Douglas Gordon
February 11, 1999, through April 2, 2000
Dia Center for the Arts
548 West 22nd Street
New York City

Edited by Lynne Cooke and Karen Kelly
Assistant Editor, Bettina Funcke
Designed by Bethany Johns, New York
Printed in Germany

Library of Congress Catalogue Card Number 00-103200

ISBN 0-944521-37-1

Distributed by
Distributed Art Publishers
155 6th Avenue, 2nd floor
New York, New York 10013
(800) 338–BOOK

All images by Stan Douglas are reproduced courtesy of the artist.
All images by Douglas Gordon are reproduced courtesy of the artist.
Usage of images from Otto Preminger's *Whirlpool* are courtesy
Criterion Pictures, Inc.
Pages 2, 32–38, photographs by Stuart Tyson.

Major funding for this exhibition was provided by the Lannan Foundation
with additional generous support from agnès b., New York and Paris,
the British Columbia Arts Council, the British Council, the Department
of Foreign Affairs and International Trade of Canada, New York State
Council on the Arts, and the members of the Dia Art Council.

Contents

Foreword

For the second time in the exhibition program, Dia presents the work of artists in tandem. "Double Vision" pairs extraordinary new works by Stan Douglas and Douglas Gordon in a unique confrontation that solicits unexpected comparisons.

Dia's principle of long exhibition durations, a minimum of one year, is particularly noteworthy for "Double Vision," as each of the works benefits from the opportunity afforded by multiple or extended viewings. The scene depicted in Stan Douglas's double-screen video work *Win, Place, or Show* is reconstructed and reedited in countless variations in real time by a computer; a viewer will undoubtedly discover literally a new point of view each time the scene repeats, leaving one wondering whether the emergent multiplicity of readings and conclusions is brought on by the structure of the work itself or by a natural impulse for reinterpretation.

For *left is right and right is wrong and left is wrong and right is right*, Douglas Gordon appropriated a feature-length film, showing it in its entirety. But Gordon's altered version of the film, its frames split into two screens and its soundtrack bouncing from one speaker to another, easily becomes physically unsettling, consequently hindering an extended stay in the installation. Still, the film's narrative, a murder-mystery drama critical to the work's comprehension, combined with its continuously Rorschaching images, induces the desire to return to witness different scenes from the film and fresh image combinations.

It is due to the insight of curator Lynne Cooke that we have the occasion to experience this provocative juxtaposition. Additionally, we'd like to thank the artists for their interest in and unwavering dedication to realizing new works for "Double Vision." Karen Kelly, Director of Publications, deserves credit for creating a book that echoes the pairing of the two artists' work. We'd also like to acknowledge Bethany Johns, who has designed a fluid publication that mutually complements the artists' works.

Major funding for this exhibition was provided by the Lannan Foundation with additional generous support from agnès b., New York and Paris, the British Columbia Arts Council, the British Council, the Department of Foreign Affairs and International Trade of Canada, New York State Council on the Arts, and the members of the Dia Art Council.

Michael Govan

Director

Lynne Cooke

Introduction

Very different in crucial respects, the oeuvres of the Canadian Stan Douglas and the Scot Douglas Gordon nonetheless betray telling parallels and shared interests. Both artists work primarily with film and video, generally presenting these media in the form of installations. Both use found footage—documentary and fictional—as well as directing and producing their own material. Both have focused on sound in its own right, on music and on film scores. Both have frequently employed techniques involving bifurcation, doubling, and inversion for structural and thematic ends. Both apportion critical roles to time in its manifold guises.[1] And both, in addition, have taken on the role of curator: Douglas orchestrated a touring show of Samuel Beckett's *Teleplays* in the late 1980s, while Gordon has compiled programs of films formerly banned in the countries where his screenings took place.

In part, these parallels might be attributed to the related circumstances that surround their formations. Growing up in British or former British societies during the 1970s and 1980s, these two young artists were subject to similar cultural imprinting. More-over, as students, they located their artistic heritages in Conceptual Art of the '60s and '70s, as well as in film and video histories. Subsequently, they have been drawn to popular genres for much of their source material, and, to somewhat different degrees, each has engaged with new technological developments in order to effect an idea or a concept, though Gordon generally prefers his work to appear immediate, simple to realize, and transparent in its mechanics.

"Double Vision" is comprised of two new installations, both of which utilize dual projection. Although it has previously appeared in their respective oeuvres, that structure reappears here fortuitously, for these works were conceived independently, without consultation. Each artist has, however, been keenly aware of the other's practice, not least because they have often found themselves participating in the same group shows. When juxtaposed, *Win, Place, or Show* (1998) and *left is right and right is wrong and left is wrong and right is right* (1999) reveal additional, if somewhat serendipitous, correspondences. More importantly, comparison may permit the singular concerns informing and governing each to emerge sharply.

Win, Place, or Show takes as its point of departure the fundamental transformation of civic space that occurred in North America during the postwar era, initiated at an institutional level under the rubric of "urban renewal." In Vancouver, the campaign against "urban blight" began in 1950 when the city commissioned a plan for the

redevelopment of one of its poorest neighborhoods, Strathcona. In this proposal, all existing structures were to be demolished in favor of a dense grid comprised of apartment towers, row housing, and a pair of dormitories for retired seasonal laborers. In *Win, Place, or Show* two dockworkers share a tenth-floor, one-bedroom apartment in one of those planned, but never constructed, dormitories. Continually looping, this six-minute work chronicles an antagonistic conversation that flares up on a wet day off: after erupting into physical violence, the antagonists lapse into weary irritation, only to rekindle their smoldering verbal friction.

Douglas shot his scene in the gritty realist style of *The Clients*, a Vancouver-produced CBC television series, which aired briefly in 1968 and whose concise parables did not abide by conventional rules of television drama: the employment of long takes, the absence of master shots, and the inarticulateness of leading characters were among its signature features. Filmed from twelve separate camera angles, Douglas's takes are cut together in real time by a computer during the exhibition, thereby generating an almost endless series of montages, since every time the scene repeats, it repeats differently. The fractured and fissured representations that result range across the spectrum, from an almost seamless illusion to a doubled image, to two completely contradictory views. In this way Douglas not only deconstructs the conventions and values integral to the style, the genre, the medium, and even the art form he employs but, by highlighting devices of disidentification, foregrounds the conditions and terms of spectatorship and, by extension, indicts as false any encompassing ideology.

Read metaphorically and metonymically as an investigation into larger issues concerning the control of social space, both in its private and public guises *Win, Place, or Show* fits within an ongoing thematic in Douglas's oeuvre in which he skeptically probes the legacy of modernism, cauterizing its obsolete or unrealizable utopian dreams. "The memory of a history that never transpired," in effect, it also completes a trilogy with *Nu·tka·* (1996) and *Pursuit, Fear, Catastrophe: Ruskin, B.C.* (1993), which, respectively, draw on the colonial and postcolonial history of British Columbia in order to examine issues of territoriality and the political relations based in class, race, and economics that subtend and sustain it.[2] A liminal space suspended precariously in time lies at the core, not only of this series, but of many of his projects: "I'm always looking for this nexus point, the middle ground of some kind of transformation," Douglas avers, adding, "I guess this accounts for the embarrassingly consistent binary constructions in my work. Almost all of the works, especially the ones that look at specific historical events, address moments when history could have gone one way or another. We live in the residue of such moments," he contends, "and for better or worse their potential is not yet spent."[3]

Yet this intricately layered work is equally open to psychoanalytical readings, as the artist himself readily acknowledges: "[it] is less concerned with the narration of the event than with the space of its unfolding, like the obsessive remembrance and reconsideration of a traumatic incident in one's life that cannot be resolved because its true cause was elsewhere, and remains unavailable to the space of memory."[4]

left is right and right is wrong and left is wrong and right is right appropriates a little-known film made in Hollywood in 1949 by Otto Preminger titled *Whirlpool*. Gordon has edited this generic example of film noir so that all the odd-numbered frames are placed onto one video disk, the even on another: black leader occupies the space of those frames absent from each. When they are projected side by side, the one on the left is reversed. The original soundtrack has been similarly treated.

Preminger's plot centers on two principals: Ann Sutton, the wife of a wealthy psychiatrist who suffers from insomnia and kleptomania, and David Korvo, a hypnotist who persuades her to undergo his treatment after saving her from being charged with theft. In order to cover up his murder of socialite Theresa Randolph, from whom he had extorted large sums of money before she threatened him with exposure, Korvo plans to hypnotize Ann and send her to Randolph's house where she will be arrested for the crime. Although he had initially and falsely suspected his wife of having an affair with Korvo, Ann's husband comes to believe that Korvo actually committed the murder under the influence of hypnosis, which gave him the strength to leave the hospital bed where he was recovering from an operation (the source of his perfect alibi). The police take Ann to the scene of the crime so that her husband can attempt to reconstruct the event. Realizing that incriminating evidence remains there that would reveal him to be the real killer, Korvo once again returns under hypnosis to the house, where he finally succumbs.

The stroboscopic flicker in Gordon's installation engenders a strong visceral impact, mimicking the act of hypnosis on which the film's plot turns, while the jarring, rending rhythm of its address conjures that required to effect a violent abreaction. The reflected symmetries of the double projection similarly serve to restructure vision; for the flow of enantiomorphic images constantly oscillates, sometimes splitting apart to insist on dual contradictory points of view, sometimes dissolving into a fully coherent if illogical space, or a single, unified entity. Often a new reality supervenes over the inverted pair of images, a reality that metamorphoses out of the seam, the junction between the two frames, and conjures yet a third vantage point: elusive, fluctuating, subliminal, it evokes a consciousness resistant to the twin claims of hypnosis and psychoanalysis.

Psychic disorder is at once the key to this narrative and a subject at the heart of Gordon's art, since it provides the occasion, in works based sometimes in fact, sometimes in fiction, for a study of fundamental existential dilemmas: between good and evil; freedom and necessity; existence and nonexistence. Gordon has variously instantiated this dialectical tension, manifesting it by slowing down the projection, doubling, inverting, repeating, or subjecting it to more complex techniques, as found here. Although his subjects frequently include split personalities, doppelgängers, and twins, he claims that he doesn't believe in dichotomies, even if he is obsessed by them.[5] Nonetheless, through recourse to such motifs and means, he gives incisive, aphoristic form to altered states, which imprint themselves on the body or manifest themselves in abnormal behavior, and which have been labeled diversely, depending on the discourses used in their analysis: madness, demonic possession, trauma, psychosis, moral turpitude, hysteria, euphoria, trance, mystical transport, hallucination, and so on.

Notes

1. Both, for example, have drawn on the works of Alfred Hitchcock, as well as early documentaries. Most of Douglas's work in other media consists of series of photographs, which relate to the sites of his installation projects. Gordon's, by contrast, ranges more broadly in type and medium.

2. See George Wagner, "Discounted Blights and Historical Evasions," in *Stan Douglas* (Vancouver: Vancouver Art Gallery, 1999), p. 89.

3. *Stan Douglas*, conversation with Diana Thater, in *Stan Douglas* (London: Phaidon Press, 1998), pp. 28–29.

4. Stan Douglas, project proposal, Dia Center for the Arts, New York, 1998.

5. See Douglas Gordon and Liam Gillick, "Sailing Alone Around the World," *Parkett*, no. 49 (1997), p. 74.

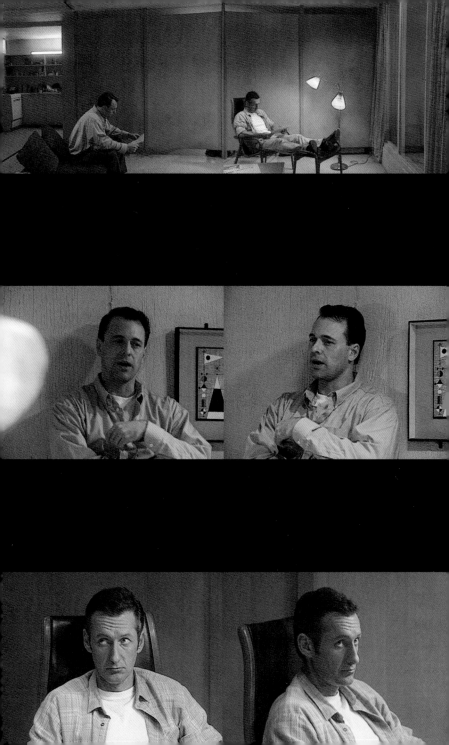

Site/Stake/Struggle: Stan Douglas's *Win, Place, or Show*

Win, Place, or Show (1999) reflects Stan Douglas's continued engagement with historic struggles over the control of social and symbolic spaces in its attention to two concomitant aspects of modernization in 1950s and '60s North America, the drive toward "urban renewal" and the rise of television as mass media. From the dreamlike, split-apart and reattached landscapes of *Der Sandmann* (1995) and *Nu·tka·* (1996), where sutured gaps provide an index of middle-class anxiety and colonial paranoia, to documentary photographs of the void constituted by an economically devastated, inner-city Detroit (1998), Douglas's work renders social occlusions and absences palpable in order to address conflicts arising where material and phantasmatic domains of experience converge. *Win, Place, or Show* similarly foregrounds this convergence. Shot in the style of the 1968 Canadian Broadcasting Corporation's semidocumentary drama *The Clients*, and set in a housing project designed—but never built—for the neighborhood of Strathcona, a low-income area repeatedly zoned for "redevelopment" by the City of Vancouver Planning Department throughout the 1950s, Douglas's latest video production situates itself between television's mass-cultural imaginary and the concrete realities of postwar urban development. Yet this simple alignment, between the media as site of collective fantasy and the city as actual locale, is immediately complicated. Never actually completed, the housing project featured in *Win, Place, or Show* is more imaginary than factual, whereas viewers will immediately recognize the "realism" of the televisual style it imitates to excess. And like Samuel Beckett's *How It Is* (1961), *Win, Place, or Show* features a rather unusual form of domestic cohabitation, as well as a similarly unusual configuration of not-exactly-public, not-exactly-private space:

Two tired longshoremen, squeezed together in a small room in a modernist housing project designed for single, working-class males, attempt to engage each other in various communicative exchanges. Don tries to get Bob to talk about occult phenomena and conspiracy theories, as well as respond to a joke; in both cases the response desired is withheld. Bob tries to get Don to play a horse-betting game, but fails. At this moment the two come to blows, falling to the floor together during the fight. After this physical struggle dissipates, due to mutual exhaustion, the characters (each breathing heavily) separate. Once their panting stops, the cycle begins again.

Two old men, pressed tightly together and face down in mud, are caught in a seemingly infinite cycle of repetition. Having crawled toward and squeezed himself against Pim, Bom forces him to tell stories and answer questions by thumping and prodding him. Some time after this physical interaction, Pim drags himself away to another site in the mud, in order to silently thump and prod another man waiting there for him. Meanwhile the original tormentor waits for the arrival of another man, who will in turn use physical means to force him into speech.

The imagined but never fully realized environment in which *Win, Place, or Show* takes place (a vertical stacking of male workers in bifurcated bachelor units, as planned by the designers of Vancouver's Worker's Domicile Project) bears a disturbing resemblance to the horizontal stretch of paired-up Boms and Pims. Foregrounding the antagonistic intimacy between men in cramped spaces, both spatial organizations provide a context for brutally forced or simply ineffectual modes of symbolic exchange in which the ordinary desire for swapping "bits and scraps" of language leads to violence and separation. In this manner, Douglas and Beckett depict a hypermasculine world in which even the simplest and most minute rhetorical acts are inextricable from relations of power, and in which individuals are always small subjects inscribed in larger systems.

Across different media, both artists share formal preoccupations with permutation and a mode of repetition that paradoxically foregrounds difference rather than sameness, as evinced in Douglas's frequent reliance on looping techniques whose effects are primarily disjunctive rather than coherence-producing. In such uses of repetition, the aim is to be "precise, but inexact," resulting in dissimulating overlaps rather than the comforts of reflexivity. While earlier works such as *Deux Devises: Breath and Mime* (1983), *Hors-champs* (1992), and *Der Sandmann* all rely on "precise inexactitude"[1] in the form of spatial and temporal splits, doublings, and fissures, *Win, Place, or Show* deploys this disjunctive device in a different sense. Here formal differences, based on specific attributes or qualities, are eroded and replaced by modal differences, based on intense variations or individuating degrees.[2] Thus the theme of class struggle in *Win, Place, or Show* is presented, not in terms of a direct clash between ruling-class city planners and working-class residents (conflict based on a formal or conceptual, easily recognizable difference), but in terms of the less culturally visible, less easily categorizable difference between a slightly older dockworker who gives the impression of being a longshoreman lifer[3] and a younger dockworker previously employed in his father's furniture factory.

This increased focus on modal over formal difference sets *Win, Place, or Show* apart from previous works by Douglas structurally as well as thematically. Whereas the temporal and spatial dissonances in *Hors-champs* and *Der Sandmann* are primarily achieved through the device of multiple projections or narratives, here the disidentificatory effects of this splitting are compounded by the twenty points of view used to record Don and Bob's interaction, shot from cameras placed at ten different angles per axis side to provide two views of the same scene. When projected simultaneously on two wall-sized screens, these opposing points of view, with the particular relation between them changing each time (due to a laser-disc system programmed to randomly

juxtapose takes), violate both the spatial continuity maintained in live television programming (also based on using multiple cameras, but from only one side of the action taking place), as well as the axis rule of eyeline matches that filmed television shows adopted from classic cinema. Posing a challenge to the normative syntaxes of its medium, this proliferation of *small* differences—differences without predetermined concepts or values—solicits the seemingly incompatible affective responses of both astonishment and fatigue. *Win, Place, or Show*'s two-channel projection offers some 200,000 variations of the exhausted dockworkers' interaction, continually reassembled by the computer and presented in looped segments of approximately six minutes each.

Through tropes of turning and returning, Douglas's persistent focus on how psychic operations and social realities organize and inform each other mirrors one of the theoretical principles to which Louis Althusser described himself as returning in one of his most well-known essays; namely that in ideology (an "imaginary" relation to the real conditions of one's social existence), the phantasmatic and material are revealed as inextricably linked. "I return to this thesis: an ideology always exists in an *apparatus*, and its practice, or practices. This existence is material."[4] Writing near the close of the decade, in the face of an intensified expansion of state-mediated cultural and communications institutions in response to social unrest throughout the 1960s, and in particular the 1968 student and worker uprisings in France (the year in which *Win, Place, or Show* situates the minor struggle it depicts), Althusser observes that one of the most significant peculiarities of ideology's imaginary-yet-material structure is that "it imposes (without appearing to do so, since these are 'obviousnesses') obviousnesses *as* obviousnesses"; obtaining from subjects "the *recognition* that they really do occupy the place it designates for them as theirs in the world, a fixed residence."[5] In the curiously fixed yet unfixed residence *Win, Place, or Show* depicts, the "*So be it*" Althusser uses as exemplary expression of this "obvious" recognition is paralleled in Bob's statement, "It is what it is," an oddly deterministic assessment of the chance game he wants cohabitant Don to play.

Bob and Don's relationship in *Win, Place, or Show* seems to consolidate specifically around site, stake, and struggle—the three terms Althusser identifies as fundamental to the question of how ideological "apparatuses" function in any given state: "Ideological State Apparatuses may be not only the *stake*, but also the *site* of class struggle, and often of bitter forms of class *struggle*." The site is an inhospitable, or literally uninhabitable (that is, counterfactual), living space: the unit in a housing project planned but never finished. At stake is what we might call ordinary, convention-based discourse: Bob and Don's efforts at joke-telling and, perhaps more significantly, horse-betting: a "nickel game" in which stakes are at once too high and too low. *Win, Place, or Show*

calls attention to the fact that it is precisely the frustration of these minor efforts at linguistic play that leads to physical violence—a struggle that produces not resolution, but a repetition of the very conditions leading to conflict.

The eventual failure of these communicative exchanges, here defamiliarized and estranged, is ironically foregrounded by the "obviousness" or seemingly innocuous presence of media as an unstoppable form of white noise. While the two men in *How It Is* are surrounded by an auditory blur, described by the narrator as "quaqua on all sides," all exchanges between Don and Bob are accompanied by the undifferentiated murmur of a radio playing elevator music, which bitterly resigned Bob describes as "noise while you do something else." This murmur (itself a syllabic doubling or repetition) is also described by Don as a homogenizing and unifying component of a larger system encompassing them: "Ever notice, wherever you go, radio sounds the same? . . . The radio stations, the papers, they could all be from anywhere, right? Even here sounds like that. All the same." For Don, more paranoid than Bob, these representational systems are totalized and fully deterministic, much like the situations he brings up in order to counter Bob's assertion of one's capacity, albeit negative, for personal control. As a rejoinder to Bob's comment, "It's just radio. . . . At least I can turn it off when I want it off," Don offers the following three variations:

Some things you don't have a choice. Like this kid in England watching television. He just sits there, can't turn it off. His mother comes in, sees him like a zombie and POW! The shock of turning it off kills him, right there on the spot. Dead from TV. No one made him watch it, but once he started—game over.

Some things you don't have a choice. Like those scientists out working on computers, plotting how everything moves. They figure that out—they'll be looking into the future. And before we even get a sniff of next week's news, the fat cats will have bought and sold it three times over.

Some things you don't have a choice. Like those tugs that keep going down. 40 boats on the bottom and 47 people dead in eight years. All in a triangle from Burrard to the Fraser to up around Sechelt. So if you think about it, there'll be 300 more people drowned out there before the end of the century.

In spite of their hyperbolic quality, Don's speculative theories about the instrumentality of abstract, all-controlling systems (whether representational, scientific-technological, or supernatural) actually underscore a logic intrinsic to *Win, Place, or Show*'s technological design. Here the idea is that while the apparatus makes room for chance variations, hence containing a structural instability, "options" available to subjects are ultimately established in advance. Just as next week's news is destined to be "bought and sold . . . three times over" before being presented to viewers, Don and

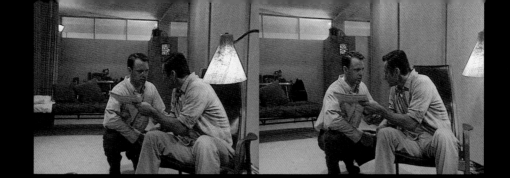

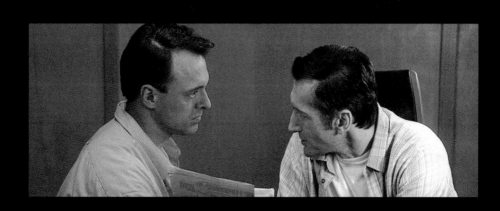

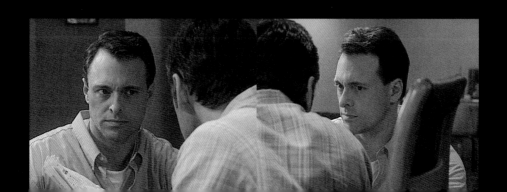

Bob are guaranteed to come to blows each time, even though "the particular causes leading to conflict and the means of representing these possess the random element that would seem to offer relief from the inevitable but inconclusive violence."[6] Recalling the fixed time slots for advertising in standard broadcast entertainment, or the fixed residences unquestioningly inhabited by Althusser's subject in ideology, in this situation there can be no genuine choice; only the taking-up of predetermined places or discursive positions. Hence: win, place, or show. Or as Bob puts it, "First, second, third—that's it." Thus while the constant fragmentation of identifying shots by the installation's machinery undermines any attempt at stable viewing positions, the viewer nonetheless remains caught in oscillation between Bob's cynicism and Don's paranoia. A defeating cycle becomes perpetuated here: Don's efforts to comment on, interpret, or produce meanings from a set of given circumstances only further mystifies these conditions; Bob's attempt to debunk Don's mystifications ultimately takes the form of cynical resignation and a refusal to interpret at all. Thus Don's attempt to assert some form of interpretive agency in the activity of horse-betting, countering its original reduction by Bob to "simple math," is ironically curtailed by the way Bob satirically responds to this desire for analysis. Bob deliberately twists his interpretations of the bits of information supplied on each horse so they become forms of insult to Don, in an aggressive assertion of the seemingly minor social difference between them: "'Would prefer less pace': that's about a horse who'd rather sit around and do nothing all day with his thumb stuck up his ass." In a sense, Bob and Don play roles analogous to Herman Melville's Ahab and Ishmael with respect to the whaling industry; the former wants to assert forms of physical control within the system ("I can turn it off when I want to"), while the latter, having surrendered control through a willing fascination, merely wants to analyze it. Yet between the perspectives of *Win, Place, or Show*'s two characters, any effort made to control or understand the system and its mechanisms ultimately ends in the acquiescence that the system is not only uncontrollable but unanalyzable to boot. "Some things you don't have a choice"; "It's just a game, shitheel! It is what it is."

There are times when art engaging in ideology critique, or willing to assume a politicized stance with respect to social issues, falls into a trap of assuming itself outside ideology in general—a particular risk for artists emulating, or self-consciously working within, the conventions of the representational systems they interrogate. Often resulting is the production of merely smug and inert ironies, rather than interesting and productive ones. One presumption suggests that the act of unconcealing the typically hidden mechanisms regulating "social visibility and nonvisibility" (exposing film's instrumental or technical base, exaggerating the presence of the camera, etc.),

or foregrounding processes of representation over represented content, *in itself* necessarily ensures freedom from ideological coercion. This perspective can often be found in the canonical theoretical discourse surrounding narrative film and television in the wake of the 1960s. Reflecting a late '60s turn from phenomenological to sociopolitical analyses of media practices, the frequently iterated argument in these discussions is that narrative forms of commercial broadcast entertainment depend on "unseen apparatuses of enunciation," whose concealment must be maintained in order to insure the imaginary identifications conferring continuous and stable forms of subjectivity to viewers, and in order to sustain an overall sense of fictional plenitude and coherence, always covering over the structuring losses (multiple cuts, negations, and exclusions) that constitute the representation to begin with. For some theorists, the implication then is that by disclosing previously effaced signs of production, or simply reshifting emphasis from the fiction to the level of enunciation, one manages to circumvent "the basic cinematic apparatus's ideological effects"—an assumption complicated by Althusser's insistence that there can be no "outside" to ideology, regardless of how strongly the disjunction is stressed between levels of enunciated content and enunciation by laying bare processes of representation.

It is this very lack of an "outside" to ideology, or to the vast and intricately interconnected abstract systems (economic, political, representational) determining "the subject" as such, that is for Douglas the starting point from which the reconfiguration of determining contexts becomes possible. Since exposure of the signifying mechanisms regulating visibility is never an aesthetic endpoint in itself for Douglas but a beginning, it comes as no surprise that his work directly confronts this more complicated issue— one that cannot be resolved simply by increased emphasis on a level of enunciation over enunciated content, or by dramatically "disclosing" representational processes previously hidden. For in its hyperbolic breakdown and proliferation of viewing positions, based on shot combinations from twenty different cameras *all* functioning as "apparatuses of enunciation," *Win, Place, or Show* dramatizes the fact that sites of enunciation/inscription are themselves rarely unified or stable—nor as easy to locate and identify as one would imagine. One cannot speak of *the* level of enunciation here, since there are numerous ones constantly shifting and in flux. Moreover, the often automatic recourse to "unmasking" this supposedly consistent level of discourse becomes a somewhat moot procedure in *Win, Place, or Show*; in a sense there is nothing to disclose or unearth here, because nothing is buried or hidden. Rather, apparatuses of enunciation are exposed and visible to begin with, displayed on the work's very surface.

Not only are *multiple* sites of inscription simultaneously displayed, making a unified point-of-view impossible, but this absence is further emphasized by the fact that the sites are themselves unfixed and constantly changing. The apparatus's combinatory function moreover insures that the particular spatial relation defined by each para-tactical juxtaposition of viewpoints (the larger angle formed *between* the two angles) will be different each time. In this sense, the relationship at stake seems less that of enunciated content to level of enunciation (a formal distinction), than the degree-based relationship between *various* levels of enunciation (a modal distinction). Because of this extravagant proliferation and insistent play of chromatic differences, the shot-to-shot relationships conventionally used to establish and analyze televisual syntax cannot be relied upon for the same purposes: "syntax" as a system based on formal or conceptual differences itself becomes troubled.

With such intense and continuous variation of shot transitions (one interfering with their normal capacity to serve as "the basic element of [filmic] organization"[7]), the apparatus in *Win, Place, or Show* seems designed to transpose the hegemonic signifying economy or "major language" of television into a "minor" one: as Gilles Deleuze and Félix Guattari have argued, not simply producing a sublanguage, but rather establishing a minor practice *of* the major language[8]—a process Deleuze elsewhere eludicates through the motif of stuttering.[9] In its visual enactment of this stutter, or oscillation, *Win, Place, or Show* demonstrates that exaggerated conformity to a representational system's signifying laws (say its internal logic of "continuous variation") might be thought of as one particular minorizing practice; here the aim is not to transgress the law by somehow ascending above it, critiquing it from some "privileged place," but "to overturn the law by descending towards the consequences, to which one submits with a too-perfect attention to detail."[10] Excessive obedience offers an irony from below rather than above, an irony that is dynamic (though in the sense of stumbling and falling), rather than the inert or formal kind, which devolves into pure cynicism. Thus Don's "Canadianness" becomes apparent precisely at the moment in which he reverently invokes Pittsburgh as a "*real* big city"; an exaggeration of a stereotypical "minorness," or localness, which nonetheless critically points to itself in tension with the major or dominant presence (of American cultural, economical, and political interests) in North America overall. In true irony-from-below fashion, *Win, Place, or Show* "minorizes," not just by foregrounding its character's seemingly willing submission to this major discourse, but through the very act of deploying, or descending to, the stereotype which Don's naiveté illustrates: Canadian "provinciality" positioned in deference to American cosmopolitanism.

Deleuze and Guattari have also argued that such acts of minorization constitute a micropolitics, "link[ing] up in a direct manner with the political question of minorities."[11] Here "minorities" are defined not in terms of a quantitative difference from majorities but as the people who are discovered *missing* immediately upon being evoked or addressed, as social formations produced by trajectories of displacement or flight.[12] In *Win, Place, or Show*, as in *Nu•tka•* and the Detroit photographs, minorization is similarly connected to the issue of absent people, but also to the occlusion of the symbolic and social spaces their presence would have defined. Thus it is concerned with the spaces from which utterance and events are *not* made or depicted (sites of *non*enunciation, or of *failed* or *unperformed* enunciation), as well as the fictitious or nonexistent spaces from which utterances nonetheless seem to emanate (*non*sites of enunciation).

Both of these negatively constituted sites could be described as locales at odds with themselves, much like the isolated room which Bob and Don inhabit: a room whose boundaries seem all too rigidly defined, yet whose internal dimensions are constantly shifting and varied, placed in dizzying oscillation through the seemingly endless permutations of juxtaposed camera angles. This leads to the production of a paradoxically "bounded yet abyssal" space. In an analysis of noir fiction and film—stylistic precursors of the television crime drama *Win, Place, or Show* consciously imitates (hence anticipating the later genre's negotiations of the urban space carefully limited by postwar architecture and city planners)—Joan Copjec describes this space as one that "contains *an excess element, its own limit*, and this limit alone is what guarantees the infinity of its contents, guarantees that an unlimited number of objects may be pulled out of it."[13] For Copjec the corpse functions as "'the trace of the unnarrated,' that without which the narrated world [and its inhabitants] would cease to exist."[14] Though her exemplary narratives are set in Los Angeles rather than inner-city Vancouver, Copjec's argument in "Locked Room/Lonely Room" has much bearing on the organization of symbolic and social space in *Win, Place, or Show*: "The logic that says that an element is added to the structure in order to mark what is lacking in it should not lead us to imagine this element as an isolatable excess *hidden beneath the structure*. The excess element is, instead, *located on the same surface as the structure*, that is, it is manifest in the latter's very functioning."[15] Here we might recall that *Win, Place, or Show*'s combinatory apparatus ensures that the lack of a unified or coherent "site of enunciation" is marked by a similarly "surface" display of excess, evinced in the exaggerated proliferation of multiple viewing positions. Just like "the space of detective fiction," the room inhabited by Bob and Don "is a *deep space*, an infinite space, not because it

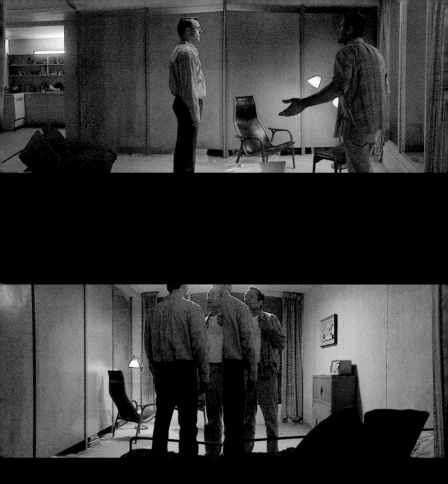
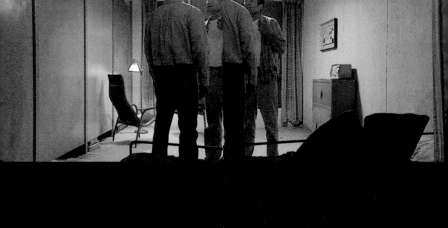
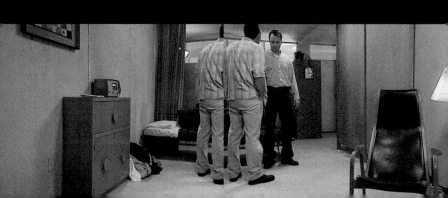

has trap doors or hidden passageways, but precisely because it does not"[16]; as stated previously, here the metaphysical peekaboo of concealment and revelation at work in older modes of ideology critique is simply not at issue.

At once flat and deep, if the locked and lonely room Bob and Don inhabit is also "a space that contains *an excess element, its own limit,*" which "guarantees the infinity of its contents," the limit here could be described as the invisible and unspoken histories of tax laws and zoning policies, corporate involvement in "urban renewal" projects, and other socioeconomic and political realities contributing to the emergence of such spaces as the one in which Bob and Don share. These factors led to "slum clearance" in largely ethnic neighborhoods and the widespread building of high-rise housing projects across North America in the 1960s, actions culminating in what *Win, Place, or Show* foregrounds as the extremely physical limitations imposed on working-class domestic life: the very boundaries, or concrete walls, of the structure in which Bob and Don live. Like the empty space defined by a missing tile in number puzzles enabling the present tiles to slide and be continually rearranged, the structural void of "the unnarrated," the uninscribed or unenunciated, could be described as subtending the surplus of enunciation positions in *Win, Place, or Show*.

Just as Copjec describes the corpse in film noir as the "trace of this unnarrated," in Douglas's work, traces of the unnarrated involve similarly done-away-with or negated entities—a missing person (*Pursuit, Fear, Catastrophe: Ruskin, B.C.*) or entire community (*Nu·tka·*), a geographic locale's excluded history. Each time, the absence becomes the driving force of the work, playing a structural as well as thematic role. Significantly *Win, Place, or Show* revolves not just around the deliberate occlusion of specific historical references (the actual data that informed the making of the work), but the absence of historicity itself. From a project description we can find out that the action depicted takes place in Strathcona, Vancouver, but otherwise there are few clues to orient the gallery viewer; in fact, the tinkle of radio music makes it sound, as Don himself notes, like it could be "from anywhere." It is supposedly 1968, yet the daily newspaper contains no discernible "news" (that is, dated or datable information); only racing schedules and jokes. No television can be found *in* Bob and Don's apartment, in spite of the fact that lighting effects and set design give their encounter the appearance of a televised docudrama. Nor does this encounter itself lend much insight into the world outside their bachelor unit. Thus the core elements of narrative "setting"—time and location— are conspicuously missing from the work as perceived by a gallery viewer.

Thus *Win, Place, or Show* is as much about the *absence* of setting, as it is obviously *about* setting. In this sense, it is entirely about a locale "at odds with itself": a locale that is not, strictly speaking, a locale—not *located*, or locatable, at any particular

coordinates. With the exception of one exterior or "outdoor" shot, a highly artificial-looking, almost futuristic skyline of anonymous towers in a noirlike drizzle of rain, there seems to be no real outside to this paradoxically bounded yet infinite room. At once claustrophobic and abyssal, the space in which the events of *Win, Place, or Show* unfold constitutes a "setting" in which setting is actually trapped *out*. The occasion of Bob and Don's encounter as a moment of missed rather than realized opportunity, specifically points to discursive positions never fully articulated—to *lost* "sites of enunciation," or of failed or unperformed enunciation. Furthermore, just as the production of dislocated people occurs as an effect of actual contestations between peoples, these missing places emerge through conflicts based on contradictions arising precisely from the institutional practices seeking to contain them.

In the postwar period, Strathcona presented planners with the particular challenge of building a residential oasis in an inner-city neighborhood. Through their positivist approach, urban planners assumed that social ills could be rectified through the formal segregation of the neighborhood and home. Premised on a functionalist rationale of zoning, the home, suburban neighborhood, and city were compartmentalized into isolated spheres. In the home, the private areas of sleeping and hygiene were separated from the public areas of eating and socializing. Moreover, suburban residential areas were located at a great distance from the structurally deteriorating city, and the city itself was divided by greenbelts and transportation routes into areas representing its quintessential functions, such as business, industry, governance, living, and recreation. In Strathcona, this logic of rigid compartmentalization would be realized through the razing of the existing neighborhood and its subsequent rezoning into distinct areas whose dwelling plans took into account marital status and family size. Larger families were to be located at the center of the neighborhood close to green spaces, schools, playgrounds, and other amenities. Single men, on the other hand, were placed on Strathcona's outskirts—their dorms relegated to a space segregated from the community's center by a major thoroughfare. In this sense, the bird's eye view from Don and Bob's apartment serves as an unrelenting reminder of the way liberal reformers wished to partition the neighborhood in order to valorize the nuclear family and childrearing as the basis of future peace, order, and social health.

While reviewing the racing information in the newspaper, Don ponders the name of the horse "Coolie Howe" in an attempt to discern from Bob the extent to which gambling involves interpretation and agency over chance. His cursory yet halting query, "Who the hell was Coolie Howe?," provides a riddling reference to the vexed history of the locale surrounding the inner-city neighborhood of Strathcona, where immigrant laborers lived in poor conditions close to barely emergent resource

industries. Although many laborers of diverse backgrounds lived in the area populated by the city's first settlers, the Chinese were singled out as the most visibly other and thereby subjected to discriminatory practices such as head taxes, immigration restrictions, legal sanctions, and moral condemnation. In the discourse of urban reform, racial characterizations were also often used to account for the rise of inner-city gambling, prostitution, and corruption. As a result, evidence of unsanitary conditions, uncivilized behavior, and poverty were rarely attributed to exploitative conditions resulting from low wages, poor working conditions, and the racist attitudes of the affluent and powerful. Consequently, under the auspices of "slum clearance" and "urban rehabilitation," reformers were not held accountable for their failure to relocate the area's residents, leading to the displacement of numerous minority workers from Strathcona.

Although assumptions about residents' needs in the postwar plans for Strathcona were left unquestioned for many years, in the early 1950s controversy raged because the free enterprise Social Credit government of the day blocked redevelopment. They associated the project with public subsidy and socialism, anathema to their Cold War ideological outlook. It wasn't until 1957, when the city of Vancouver released modified plans for urban redevelopment, that Raymur Place and McLean Park, two high-rise sections of the neighborhood featured in documentary photographs by Douglas, were finally built. Nevertheless, by the late '60s it was clear that the reformers' modernist approaches to architecture and planning only intensified discrimination and perpetuated poverty. As a result, in 1968 when the third phase of Strathcona's redevelopment was about to be built, years of ongoing resistance by local residents and urban activists culminated in successfully blocking the project's continuation. Especially contentious at this time was the plan to run a freeway through the neighborhood.

As a counterpart to postwar attempts at functionalist planning and architecture, discourse about the social value of television was similarly controversial. As noted by Raymond Williams, the suburban single-family dwelling, nuclear family, and television became integral to the reshaping of social space, assumed to "anchor" a postwar world undergoing significant change. People and places were launched into increasingly mobile and complex relationships, thereby uprooting more established ways of life. As television mediated the relationship between the private suburban space of the nuclear family and the mobility unleashed by the forces of urbanization, industrial development, and growing media infrastructures, TV was celebrated for its ability to reconcile growth and change with social order and cultural belonging. Homeowners could receive news of other people, places, and times at a safe distance—leaving them unchallenged by cultural difference and social strife as they viewed it on television.

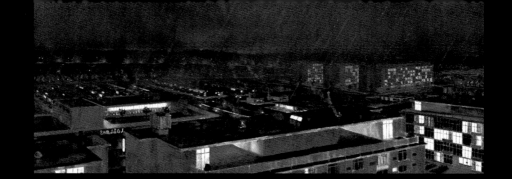

On the other hand, because television brought news of the outside world into the home, it was also regarded as a symptom of social ills. In many spheres, television was thought to be a corrupting influence. Many blamed television, as they blamed urbanization, for being the primary cause of crime, violence, and declining social morals— a moral panic reflected in Don's anecdote of a child's death by home entertainment: "No one made him watch it, but once he started—game over."

In Bob's barbed response, "Hey, whatever you say, Donny, sure. The television killed the kid. Maybe we should get ourselves a TV in here, so you can watch it all day," Douglas's narrative points to the lack of television in the men's apartment, an absence foregrounded by the fact that it is 1968, the era of Marshall McLuhan's "Global Village," which heralded the ability of electronic media to instigate a homogeneous and harmonious world order. Yet McLuhan's utopian philosophy, like that of urban reformers, is subtly undermined in *Win, Place, or Show*. Just as the cramped and worn state of Bob and Don's apartment intimates that the modernist reshaping of social space failed to instigate its promises of social, psychological, and physical health, Bob and Don seem to have little access to the universalizing prescriptions of the Global Village; a fact reinforced by their dependence on older and more established media such as the newspaper and radio. Yet while Bob and Don don't own a television, the action between them cryptically doubles as televised drama because Douglas relies on production techniques and generic styles reminiscent of live television production of the period, particularly the 1968 CBC television series *The Clients*. Shot on location in Vancouver, this semidocumentary delved into the everyday dilemmas faced by a parole officer while negotiating the rigidities of the justice system and the complexities of his clients, whose problems could not be resolved through the law. The parole officer, a good liberal wracked with ambivalence, often crossed the line between legality and criminality, illustrating the weaknesses and contradictions of the system's norms. In the local press, shows like *The Clients* were heralded as exemplary of sophisticated Canadian programming. Proponents of the semidocumentary claimed that it served as an alternative to the perceived encroachments of American cultural industries on Canadian national identity. At a time when many in the cultural and social elite associated television viewing with moral downfall and crass commercialization, the semidocumentary was held up as an example of socially responsible and artistically gratifying television programming. While loosely based on a similar fight sequence drawn from an episode of *The Clients*, the physical struggle between Bob and Don deviates from the former in its lack of resolution. The endless repetitions and permutations of this scene lead only to exhaustion, skewing the prescriptive nature of the semidocumentary, which was produced to impart a moral commentary on corruption, crime, and urban blight in a style reminiscent of Strathcona's modernist architects and urban planners.

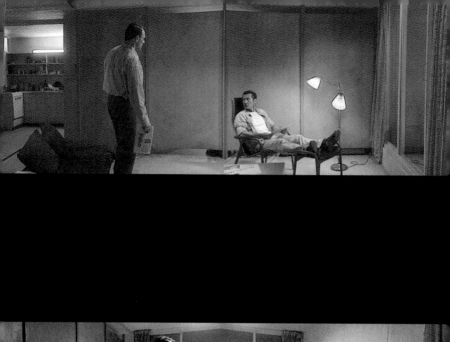

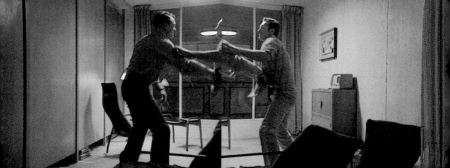

The highly specialized state-mediated institutions that expanded and proliferated in the postwar period were thus largely unified under the aegis of liberal reform, an enterprise that predominantly relied on principles of spatial partitioning and compartmentalization as immediate solutions for social ills. Linking disparate cultural institutions together, this partitional logic becomes exaggerated by the combinatorial apparatus in *Win, Place, or Show*, which not only carries the operations of bifurcation and segmentation to a vertiginous extreme but does so precisely by means of the random element that functionalist reformers sought to *eliminate* through their own practices of systematic partitioning. While deployed by these planners in the interests of neutralizing class antagonisms and maintaining a preexisting social order, *Win, Place, or Show* utilizes the same symbolic principle in order to highlight the *dis*equilibrium internal to the system, as well as the escalation of hostility between Bob and Don. In this sense, *Win, Place, or Show* suggests that class struggle is not so much localized within particular state apparatuses, but where multiple institutional discourses in their various contradictions converge—a *dissonant* convergence highlighted by the vertical seam,[17] where the interior space of the workers' apartment ceaselessly divides into itself.

The physical struggle in which the "minor" class antagonism between Bob and Don culminates (and dissipates, only to escalate again) is where spatial partitioning, here rendered dizzyingly excessive, becomes most foregrounded as a logic exacerbating the social conditions urban planners thought it would alleviate. For it is within the scuffle that such partitioning most prominently appears as a locus of *occlusion*, as if the segmentation of social space were itself responsible for the emergence of an internal void into which objects and humans suddenly disappear. Here the seam formed by the juxtaposition of two formally defined shots undergoes a sudden change in status: no longer functioning as a structural boundary marking the segmentation of interior space, but a gap paradoxically undermining the stability of these divisions. This transformation becomes most pronounced during the fight because it is the one moment in the diegesis where the two characters become physically intertwined. Thus while the viewer knows Bob and Don must be tangled together, the partition separating bounded spaces paradoxically comes to mark a zone of dislocation in which one or both subjects becomes periodically occulted from or trapped out of view. Since the conversion of partition into void becomes most apparent in montages where no overlap between the two points of view can occur (i.e., when the angle or distance between individual camera positions is at its widest), Douglas ensures that this disjunction becomes most prominent after the coin falls and dialogue ceases. For while there are six discrete moments in the narrative (Joke, Conspiracy Theory, Horses, Insult, Nickel,

and Fight) where the computer itself flips a coin to determine which variation of montage to play, the Nickel and Fight sections—the "stake" and "struggle" sections— have more than double the number of montage variations (per text) than the first four sections: eight possibilities versus three. With the greater potential for non-overlapping shots at these narrative junctures, Douglas increases the likelihood for the vertical seam's role to change: from its initial function as locus of division, or partition separating two enclosed, clearly demarcated interior spaces, to a *dislocation* at the center where dropped nickels and the bodies of tired workers seem prone to vanish, no longer locatable by any coordinates within the system itself.

Stake and struggle thus persist as central, albeit negatively foregrounded terms, as *Win, Place, or Show* perversely follows a spatializing logic to a point at which this same logic becomes rendered "at odds with itself," much like the locales featured in Douglas's other works. In this manner, the lonely room Don and Bob inhabit— a closed interior that, like ideology, seems to have no real "outside"—is nevertheless at the same time nothing *but* outside: a site that paradoxically externalizes itself through the very process of delimiting its internal spaces.

Sianne Ngai is a critic and poet. Her essays have appeared in *Postmodern Culture*, *Camera Obscura*, and *Open Letter*.

Nancy Shaw is a poet, independent curator, and critic. Her work has appeared in *Parachute*, *Semiotexte(e)*, and *Open Letter*.

The authors would like to thank Dan Farrell, Monika Kin Gagnon, and Karen Kelly for their excellent critical and editorial suggestions.

Notes

1. "Precise inexactitude" is an expression Jean-François Lyotard uses to describe Marcel Duchamp's "machinations" in his study of the *Large Glass*. See *Duchamp's TRANS/formers*, trans. Ian McLeod (Venice: Lapis Press, 1990), p. 87.

2. See Gilles Deleuze, *Difference and Repetition*, trans. Paul Patton (New York: Columbia University Press, 1994), p. 5.

3. See Stan Douglas and Peter Cummings, *Win, Place, or Show* script (January 1998). Courtesy of the artist.

4. Louis Althusser, "Ideology and Ideological State Apparatuses (Notes Toward an Investigation)," in *Lenin and Philosophy, and Other Essays*, trans. Ben Brewster (London: New Left Books, 1971), p. 166.

5. Ibid., pp. 172, 178 (our emphasis).

6. William Wood, "Secret Work," in *Stan Douglas* (Vancouver: Vancouver Art Gallery, 1999), p. 112.

7. Noël Burch, *Theory of Film Practice*, trans. Helen R. Lane (New York: Praeger, 1973), p. 12. Cited in Kaja Silverman, *The Subject of Semiotics* (New York: Oxford University Press, 1983), p. 201.

8. See Gilles Deleuze and Félix Guattari, *Kafka: Toward a Minor Literature* (Minneapolis: University of Minnesota Press, 1986), pp. 16–27.

9. See Daniel W. Smith, " 'A Life of Pure Immanence': Deleuze's 'Critique et Clinique' Project," in Gilles Deleuze, *Essays Critical and Clinical*, trans. Daniel W. Smith and Michael Greco (Minneapolis: University of Minnesota Press, 1997), p. xlix. Deleuze's "He Stuttered" also appears in this volume (pp. 107–114).

10. Deleuze, *Difference and Repetition*, p. 5.

11. Smith, p. xlvi. See also Gilles Deleuze and Félix Guattari, *A Thousand Plateaus: Capitalism and Schizophrenia*, trans. Brian Massumi (Minneapolis: University of Minnesota Press, 1987), pp. 469–470.

12. See Smith, p. xlvi.

13. Joan Copjec, "Locked Room/Lonely Room," in *Read My Desire: Lacan against the Historicists* (Cambridge, Mass.: MIT Press, 1994), pp. 176, 175.

14. Ibid., p. 174.

15. Ibid., p. 175.

16. Ibid., p. 176.

17. Carol Clover uses the phrase "vertical seam" in her essay on Douglas's *Der Sandmann*. See "Focus," in *Stan Douglas* (London: Phaidon, 1998), pp. 68–79.

Neville Wakefield

Lapse

Suspicious of everyone and everything, the film-noir detective moves through a shadow world of corruption, venality, and deceit. Sensitive to the forces that shape the under-world, he feels its pull just as he resists the temptation to be drawn in. His quest for truth leads him across borders into ambiguous places where he must blend with the darkness he seeks to illuminate, conceal himself within the very thing he seeks to uncover. Agent of transference, he is also a hard-boiled therapist consigned to the interminable task of searching out and bringing to light the concealed motivations surrounding him—of making sense of the present through the events of the past. Mimicking the process of psychoanalysis, the mechanisms of plot follow investigative knowledge as it is challenged by successive acts of deception into worlds where roles start to flicker and the polarities of good and evil are easily reversed. Here confusion reigns: perpetrators are victims, the analyst becomes the analysed, the role of the hypnotist becomes that of the hypnotized, light becomes shadow—as Douglas Gordon's title has it, a world where left is right and right is wrong and left is wrong and right is right.

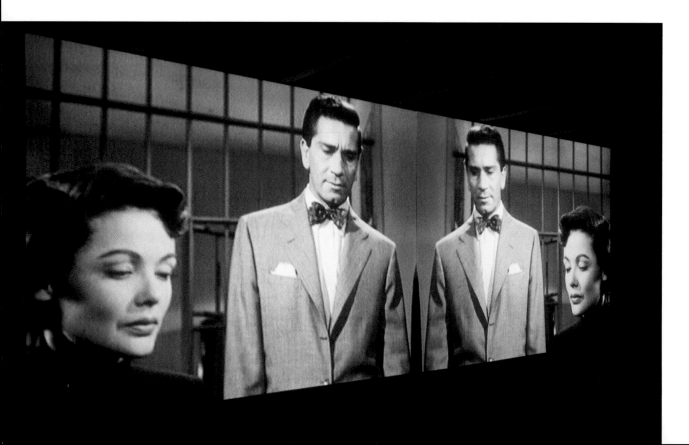

Otto Preminger's 1949 film *Whirlpool* is, as the title suggests, a psychological vortex into which all such distinctions are rendered indeterminate. The film follows the plight of Ann Sutton, the kleptomaniac wife of a renowned psychiatrist and David Korvo, a quack hypnotist who persuades her to undergo his treatment when he saves her from being charged as a thief. Sutton, grateful for his complicity in concealing the nature of her sickness (and crime) from the authorities—represented by both the police and the psychoanalytical patriarchy of her husband—agrees to attend a cocktail party thrown by Theresa Randolph, a wealthy socialite who is the subject of Korvo's extortions. When threatened with exposure, Korvo murders Randolph and plans to incriminate Sutton by hypnotizing her and sending her to the scene of the crime, where she will later be arrested. Ann's husband, who initially suspects his wife is having an affair with her hypnotist consort, comes to believe that Korvo himself committed the murder using the ruse of an operation to provide him with the perfect hospitalized and bed-ridden alibi.

The role of detective-psychiatrist falls on Sutton's husband, who establishes his wife's innocence by revealing that Korvo has successfully become his own double. Using his own hypnotic power, Korvo, it transpires, rises from his hospital bed after a gall bladder operation, thereby exploiting a sedentary somatic alibi for his predatorily criminal psyche. When Dr. Sutton shows the police investigating the Randolph case a

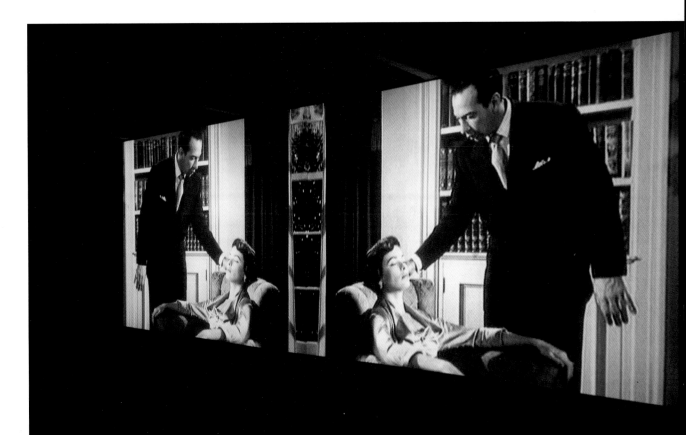

newspaper story evoking a scenario that presages scenes from David Cronenberg's 1982 film *Videodrome*—the case of a doctor who successfully operated on himself under self-hypnosis during and after which he experienced neither pain nor shock—Korvo's rock-solid alibi begins to crack. Finally, he incriminates himself when, realizing that evidence remains at the crime scene, he returns, again under hypnosis, to confront his fate.

To enter the flickering darkness of Douglas Gordon's re-edit of the film, you must first pass a public warning tacked to the wall. It cautions the viewer about a condition known as photosensitive epilepsy, a stimulus-induced type of seizure most commonly triggered in children and adolescents. For those susceptible to the condition it describes—particularly those who suffer from tonic-clonic, absence, complex partial, and mixed epilepsy—the filmic experience promised by the installation carries potentially dire medical consequences. Even for those without such a history, the suggestive power of the warning casts its own shadow across the subsequent experience, transforming the darkened temple of traditional cinema into a twilight laboratory of human consciousness. Under the smiling benignity of a sign that seems to say "we care," Gordon preconstitutes our response to the work within the language of a psychological and medical condition. Written as a warning, the sign now functions as a predisposition—the writing clearly on the wall, the experiment on us.

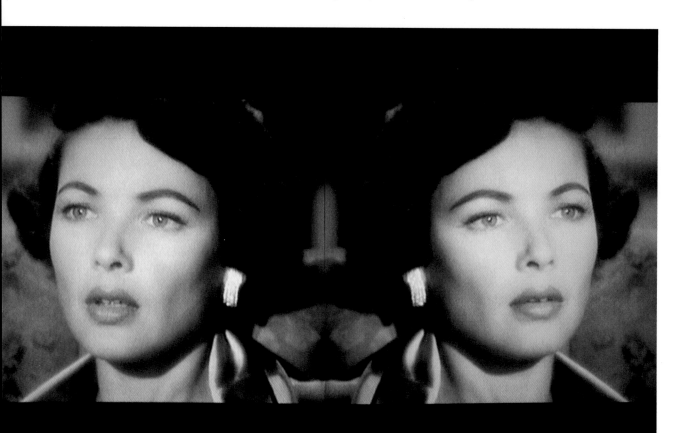

Inserting literal darkness into *Whirlpool*'s play of illness, murder, and deception, Gordon fractures the narrative structure of Preminger's film by dividing it in two: even-numbered frames from the original film appear on the left-hand screen, odd on the right, with black leader filling the emptied spaces between. With the image on the left screen reversed, the film becomes its own mirror, a representation of itself conditioned as perfected distortion. The soundtrack has undergone similar treatment: sound from the divided frames is split between two speakers—sound corresponding to the even-numbered frames emanates from the right speaker and vice versa—to create a kind of Doppler stereo governed by spatial equidistance. Radically disrupting the linear contiguity of the original film, Gordon splits its genetic code into two near identical twins rejoined along the vertical axis of a constantly Rorschaching seam.

Each half of the film is now screened as a picnoleptic discontinuum of lost moments and lapsed consciousness that parallels the unfolding narrative of the original. The experience itself is now constituted as a series of minor slippages conducted to the flicker of ongoing cognitive paralysis. Frames slip away from the reel of consciousness to migrate across borders, across hemispheres, into smaller accumulations of fragmented images—a conscious unconscious constructed out of blackouts and narrative faults. It's a form of *petit mal* most frequently experienced by children. As Paul Virilio explains:

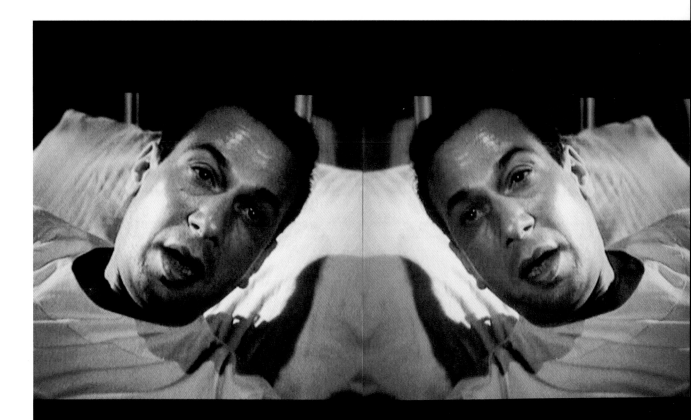

The lapse occurs frequently at breakfast and the cup dropped and overturned on the table is its well-known consequence. The absence lasts a few seconds; its beginning and its end are sudden. The senses function, but are nevertheless closed to external impressions. The return being just as sudden as the departure, the arrested word and action are picked up again where they have been interrupted. Conscious time comes together again automatically, forming a continuous time without apparent breaks. For these absences, which can be quite numerous— hundreds every day most often pass completely unnoticed by others around— we'll be using the word picnolepsy *(from the Greek* picnos*: frequent). However, for the picnoleptic, nothing really has happened, the missing time never existed. At each crisis, without realizing it, a little of his or her life simply escaped.*

Split into continuous discontinuity in this way, Gordon's treatment of the narrative of the original film recalls Louis Pasteur's insights into the unevenness of nature at a molecular level. Pasteur observed that many organic molecules can form in two different shapes or isomers, mirror images of each other, which, while chemically identical and continuous, are physically different. Since then, modern pharmacology has ignored the "handedness" of isomers produced by synthetic chemistry only at great cost.

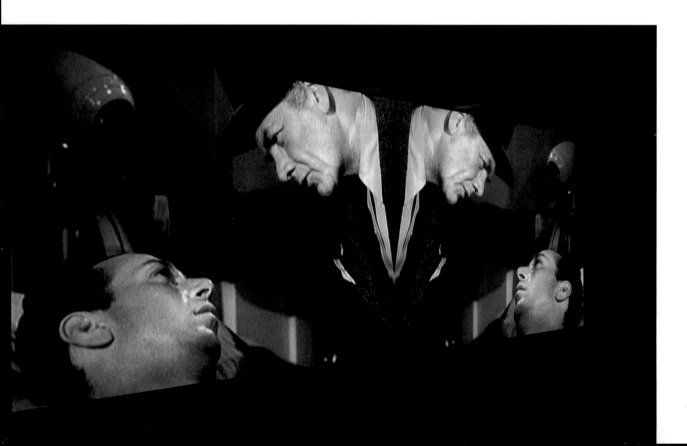

The sedative thalidomide, for example, once prescribed for the treatment of morning sickness, was originally synthesized using equal mixtures of its two-handed variants. Thirty years later, we continue to live with the dire effects of the left-handed isomer of this chemical identity for which only the right-handed portion acted in the ways intended. Resynthesizing Preminger's film by introducing the mirrored left-hand pictorial isomer, Gordon has transformed the cinematic experience into a potentially unsettling and threatening condition. Among the pulsating shadows of light and sound, the specter of physical affect refuses the comfort that casts the body as a mere upholstered seat of the imaginative mind; instead the body that we risk inhabiting, the photosensitive body of which we are warned, suggests a conjoined screening of flesh and mind, a psychosomatic mixing of medium and message.

In previous work, Gordon has produced statements of equally ambiguous address and intent. "I am aware of who you are and what you do" ran a Kurtzian missive, dated Wednesday, March 20, 1991—its message ferried back and forth between paranoia and omniscience. Ink has been spilt and entered the body of the artist whose exhortations to entrust have been issued from the prison house of his own body turned Lacanian mirror. In this he has turned his own presence, as well as that of others, into loops of corporeal celluloid, permanently scarified by light and darkness and fixed in everything but address. The question, metaphorical and factual, of these ambiguous spaces, is

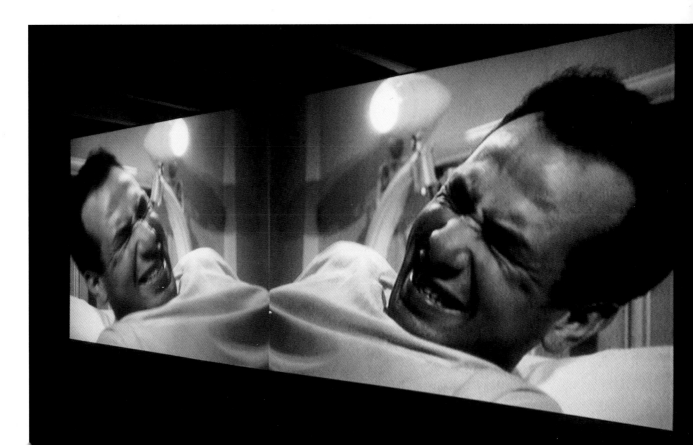

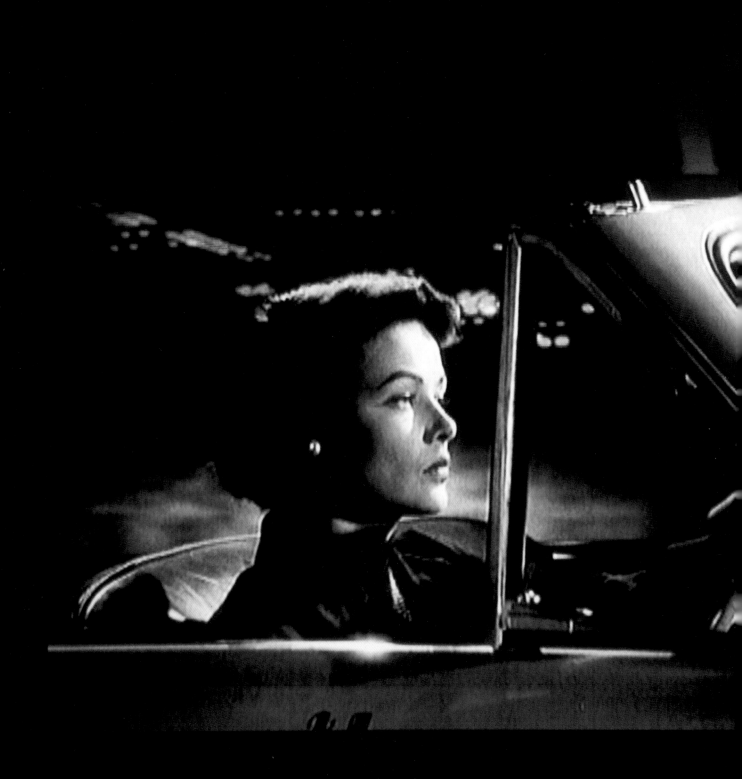

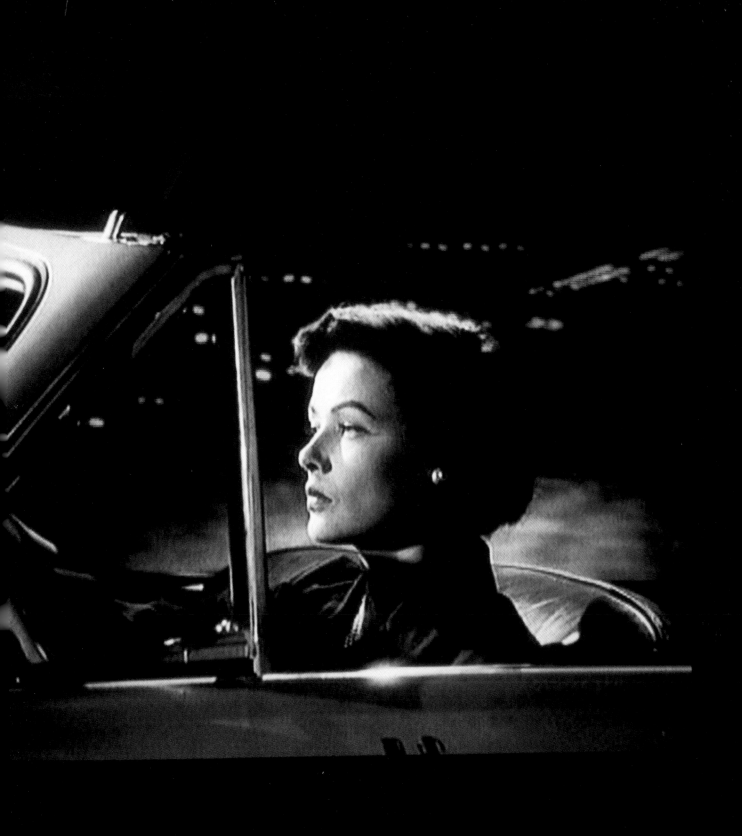

carried by him and others, written in the bodies we inhabit, in the stories we tell ourselves to live.

Three Inches Black (1997) visualizes one such story, inscribed on the index finger of a man who might have been Gordon but apparently is not. Darkness entered his body via the tip of his left hand—the hand that for the majority is without autograph and divorced from self-possession; the stuff of the word become flesh. Somewhere in the illegible darkness of the tatooist's ink lies a story relating to the young Gordon's upbringing in Glasgow during the early 1970s, a time when the city's reputation for thuggery and violence flourished in the hands of knife-and-razor-toting gangs. According to Gordon's own recollections, a contemporary of his had been arrested for carrying an object that could be construed to be an offensive weapon. The boy was carrying nothing more than a steel comb, the handle of which was long and sharp— long enough and sharp enough to be buried in the body of an assailant's victim with fatal consequences. The three inches of the subsequent piece's title referred to the depth of this penetration. "I liked the idea that the tattoo would be a sign for the distance between the outside world and the vital organs of the body—this could be read quite literally as the distance necessary to reach in and touch someone's heart."

But to commit a man to an indelible scar is an act of faith from which it becomes up to us to discern the pulpit of trust. And for Gordon trust is precisely what is at stake in this inky game with the phenomenology of the soul and the purgation of light and darkness. In *Whirlpool*, when Ann Sutton demands how David Korvo can make her forget her torment and sleep the nine peaceful and happy hours he has promised, he utters two words—*Trust me*—words the artist has inscribed on his own arm, invoking the scriptures and bringing to the messianic architecture of his body that of the church. According to Gilles Deleuze and Félix Guattari: "Society is not exchangist, the socious is inscriptive: not exchanging but marking bodies, which are part of the earth." The "trust" of Gordon's tattoo plays into such a regime of debt by bifurcating the flow of desire into separate images whose declarative power falters in the presence of the known or unknown other. The alliance-debt answers to what Friedrich Nietzsche described as humanity's prehistoric labor: the use of the cruelest mnemo-technics, in naked flesh, to impose a memory of words founded on ancient biocosmic memory. But in Gordon's case the memory of the word, like the anecdotal recollection of the Glaswegian stabbings, does not precede but rather is engendered by the word itself. In the beginnings of his world there was the word, split into its representations and made flesh.

"Beware of false prophets that come to you in sheep's clothing," intones the preacher played by Robert Mitchum in the opening sequences of *The Night of the Hunter.* So

begins Charles Laughton's timeless tug-of-war chronicle of trust and betrayal, Good and Evil, truth and deception. Bearing the insignia of opposing forces tattooed on his knuckles, the minister enacts the conflict as a single bodily lamination of the forces of spirit and the will. "H-A-T-E it was with this left hand that brother Cain struck the blow that laid his brother low. L-O-V-E you see these fingers, dear hearts, these fingers have veins that run straight to the soul of man." The wine of religion may run through the sacramental body extending its message outward into the ways and words of the world, but at the same time the process of extroversion opens its surfaces to the forces of corruption. The preacher in John Huston's film *The Great Sinner* expresses this pretty clearly: "The Church of Christ without Christ is nothing but your own shadow, nothing but a reflection in a mirror."

Preminger portrays Korvo as a classic case of disassociative shadowing—a man who moves easily among the best circles of society even as he consorts with criminals and follows a life of crime. It's a portrait that recalls the Scottish case of William Brodie, deacon of the Wrights (cabinet- and coffinmakers), gamester, cheat, bigamist, and chieftain of a gang of thieves. Brodie, who was hung in 1788, was restored to double-life a century later by Robert Louis Stevenson as the "polar twins" Dr. Henry Jekyll and Mr. Edward Hyde. "Though so profound a double-dealer," Jekyll stated, "I was in no sense a hypocrite: both sides of me are in dead earnest"—and had long been. Hyde, a pleasure-seeking corrupt, was fully half of Jekyll. In the toils of a "moral weakness," Jekyll had to face "that truth by whose partial discovery I have been doomed to such a dreadful shipwreck: that man is not truly one, but truly two."

A Divided Self I & II (1996)—a video piece consisting of two separated monitors, on each of which were shown two arms, one hairy and one shaven (both, incidentally, are Gordon's), wrestling for domination—might have been Gordon's remake of the famous scene from *The Night of the Hunter*: Mitchum's tattoos have become Gordon's arms, locked in permanent struggle over the possession of a single body. The title of the piece invokes the Glaswegian-born psychologist R.D. Laing's seminal antipsychiatric tract of the 1960s, *The Divided Self*, subtitled *An Existential Study in Sanity and Madness*. "The term *schizoid* refers to an individual the totality of whose experience is split in two main ways," writes Laing:

> In the first place, there is a rent in his relation with the world and, in the second, there is a disruption of his relation with himself. Such a person is not able to experience himself "together with" others or "at home in" the world, but on the contrary, he experiences himself in despairing aloneness and isolation; moreover, he does not experience himself as a complete person but rather as "split" in

various ways, perhaps as a mind more or less tenuously linked to a body, or as two or more selves and so on.

In his study, Laing asks how remedial psychiatry can hope to address the human relevance and significance of the patient's condition so long as the words that it uses are designed specifically to isolate and circumscribe the meaning of a patient's life to a particular clinical entity. A scene in *Whirlpool* echoes Laing's warning: In the wake of her theft, Ann Sutton's insomnia is chronic, yet she is wary of Korvo's "cure." She succumbs only when Korvo reminds her that knowledge is power: "The fact that I know of your kleptomania, the fact that I know your mind is sick gives me a medical position in your life—doesn't it?" he states rhetorically. Psychiatric medicine is thus represented as just another form of blackmail, exploiting inequality in the fight for the possession of a body through the mind. Korvo realizes that surveillance is control, that the mere act of observation is sufficient to polarize the normal and the deviant. To the question posed by Laing, Korvo simply reinstates the split psychiatric mirror. Evoking this dichotomy, Gordon seems to suggest that psychiatry may be the late century's false prophet.

In the preface to *Madness and Civilization*, Michel Foucault's *History of Insanity in the Age of Reason*, he describes his project as one of attempting to find the ground zero of madness, "at which madness is an undifferentiated experience, a not-yet-divided experience of division itself." Foucault argues that since the Enlightenment our understanding of insanity and the institutions of incarceration and treatment that go with it has belonged to the language of reason, a language so merciless in its imposition of separation as to generate its own particular insanity. "As for a common language," he writes, "there is no such thing; or rather there is no such thing any longer; the constitution of madness as a mental illness, at the end of the eighteenth century, affords the evidence of a broken dialogue, posits the separation as already effected, and thrusts into oblivion all those stammered, imperfect words without fixed syntax in which the exchange between madness and reason was made." With Gordon's *left is right and right is wrong and left is wrong and right is right*, we come face to face with those stammered, imperfect words and incoherent retreats, which are something like the undivided experience of such division.

Neville Wakefield is a writer living in New York. He is the author of *Fashion: Photography of the Nineties* (Scalo 1998), as well as several exhibition catalogues and monographs. His work has also appeared in *Parkett, Open City, Vogue,* and his diary.

References

Deleuze, Gilles, and Félix Guattari. *Anti-Oedipus: Capitalism and Schizophrenia*. Minneapolis: University of Minnesota Press, 1983.

Foucault, Michel. *Madness and Civilization: A History of Insanity in the Age of Reason*. New York: Pantheon Books, 1965.

Gordon, Douglas. *Letter to agnès*. Berlin, 6 October 1997.

Laing, R.D. *The Divided Self: An Existential Study of Sanity and Madness*. London: Tavistock Publications, 1960.

Stevenson, Robert Louis. *Strange Case of Dr. Jekyll and Mr. Hyde*. New York: Current Literature, 1910.

Robert Louis Stevenson: Critical Heritage. Ed. Paul Maixner. London: Routledge & Kegan Paul, 1981.

Virilio, Paul. *The Aesthetics of Disappearance*. New York: Semiotext(e), 1991.

Stan Douglas

1960
Born in Vancouver, Canada
1978–1982
Emily Carr College of Art and Design, Vancouver

Lives and works in Vancouver

One-Person Exhibitions

1999
"Double Vision: Stan Douglas and Douglas Gordon,"
 Dia Center for the Arts, New York
"Stan Douglas," Vancouver Art Gallery; Edmonton Art
 Gallery; The Power Plant, Toronto; De Pont Museum,
 Tilburg; Museum of Contemporary Art, Los Angeles
"Stan Douglas: Pursuit, Fear, Catastrophe: Ruskin, B.C.,"
 Fondation Cartier pour l'art contemporain, Paris
"Le Détroit," Art Gallery of Windsor
"Nu•tka•," Centro Cultural Recoleta, Buenos Aires
1998
"Win, Place, or Show (first version)," Kunstverein Salzburg
"Detroit Photos," David Zwirner Gallery, New York
1997
"Der Sandmann," Freedman Gallery, Albright Center for
 the Arts, Reading
"Evening," Museum of Contemporary Art, Chicago
"Photographs by Stan Douglas," Centre genevois de gravure
 contemporaine, Geneva
"Overture y Monodramas," Museo Alejandro Otero, Caracas
"Stan Douglas," Galerie Daniel Buchholz, Cologne
Central Kunstpreis, Kunstverein Cologne
1996
"Stan Douglas," Musée d'art contemporain de Montréal
"Stan Douglas," Museum Haus Lange and Museum Haus
 Esters, Krefeld
"Nootka Sound Photographs," Zeno X Gallery, Antwerp
"Two Early Works," David Zwirner Gallery, New York
"Overture," Museum of Image and Sound, São Paolo

1995
"Subject to a Film: Marnie, Overture, and Recent
 Photographs," David Zwirner Gallery, New York
"Monodramas," Neueraachenerkunstverein, Aachen
"Evening and Hors-champs," The Renaissance Society
 at the University of Chicago
"Pursuit, Fear, Catastrophe: Ruskin B.C.," Walter Phillips
 Gallery, Banff
1994
"Currents 24. Pursuit, Fear, Catastrophe: Ruskin B.C.,"
 Milwaukee Art Museum
"Hors-champs," Contemporary Art Museum, Houston
"Stan Douglas (with Diana Thater)," Witte De With,
 Rotterdam
"Stan Douglas," Institute of Contemporary Art, London;
 Viewpoint Photography Gallery, Salford
 (with broadcast)
"Hors-champs/Matrix 123," Wadsworth Atheneum,
 Hartford
"Stan Douglas," Macdonald Stewart Art Centre, Guelph;
 Art Gallery of York University, Toronto
"Stan Douglas," Musée national d'art moderne, Centre
 Georges Pompidou, Paris; Museo Nacional Centro
 de Arte Reina Sofia, Madrid; Kunsthalle Zürich;
 Witte de With, Rotterdam; DAAD, Berlin
1993
"Monodramas," Galerie Christian Nagel, Cologne
"Hors-champs," Transmission Gallery, Glasgow; World
 Wide Video Centre, The Hague; David Zwirner Gallery,
 New York
1992
"Monodramas," Art Metropole, Toronto (with broadcast)
"Monodramas and Loops," UBC Fine Arts Gallery,
 Vancouver (with broadcast)
1991
"Monodramas," Galerie Nationale du Jeu de Paume, Paris
1990
"Trois installations cinématographiques," Canadian
 Embassy, Paris

1989

"Subject to a Film: Marnie/Television Spots,"
YYZ Gallery, Toronto

1988

"Television Spots/Subject to a Film: Marnie (studies),"
Contemporary Art Gallery, Vancouver

"Samuel Beckett: Teleplays," Stan Douglas, curator,
Vancouver Art Gallery

"Television Spots (first six)/Overture," Optica: un centre
d'art contemporain, Montreal

"Television Spots (first six)," Artspeak Gallery, Vancouver

1987

"Stan Douglas: Perspective '87," Art Gallery of Ontario,
Toronto (with broadcast)

1986

"Onomatopoeia," Western Front, Vancouver

1985

"Panoramic Rotunda," Or Gallery, Vancouver

1983

"Slideworks," Ridge Theatre, Vancouver

"Two Hangers at the Jericho Beach Air Station,"
Jericho Beach, Vancouver

Selected Group Exhibitions

1999

"Notorious: Alfred Hitchcock and Contemporary Art,"
Museum of Modern Art, Oxford

"Ecstatic Memory," Art Gallery of Ontario, Toronto

"Umwelt/Umfeld," Palais des Beaux-Arts, Brussels

1998

Berlin Biennale

"Wounds: Between Democracy and Redemption in
Contemporary Art," Moderna Museet, Stockholm

1997

"Trade Routes: History and Geography," Johannesburg
Biennale, Institute of Contemporary Art, Johannesburg

"Longing and Memory," Los Angeles County Museum
of Art

Documenta X, Kassel

Sculpture.Projects in Münster 1997

"l'autre," 4e Biennale d'art contemporain de Lyon

"Sharon Lockhardt, Stan Douglas, Hiroshi Sugimoto,"
Museum Boymans Van Beuningen, Rotterdam

Kwangju Biennale

1996

Hugo Boss Prize 1996, Guggenheim Museum Soho,
New York

"Art and Film Since 1945: Hall of Mirrors," Museum of
Contemporary Art, Los Angeles; Wexner Center for
the Arts, Columbus; Palazzo delle Esposizioni, Rome;
Museum of Contemporary Art, Chicago

"NowHere," Louisiana Museum of Modern Art, Humblebaek

"Jurassic Technologies Revenant," 10th Biennale of Sydney,
Art Gallery of New South Wales

"Everything That's Interesting Is New," The Deste
Foundation, Athens; Guggenheim Museum Soho,
New York; Museum of Modern Art, Copenhagen

1995

"installation, cinéma, vidéo, informatique," 3e Biennale
d'art contemporain de Lyon, Musée d'art contemporain

Carnegie International, Carnegie Museum of Art,
Pittsburgh

"Video Spaces," Museum of Modern Art, New York

"Public Information: Desire, Disaster, Document,"
Museum of Modern Art, San Francisco

Whitney Biennial, Whitney Museum of American Art,
New York

1994

"Image/Image," Museum van Hedendaagse Kunst, Ghent

1992

Documenta IX, Kassel

1991

"The Projected Image," San Francisco Museum of
Modern Art

1990

"Passage de l'image," Musée national d'art moderne, Centre
Georges Pompidou, Paris; Fundació Caixa de Pensions,
Barcelona (video program)

Aperto '90, Biennale di Venezia

"The Readymade Boomerang: Certain Relations in
Twentieth-Century Art," 8th Biennale of Sydney,
Art Gallery of New South Wales (with broadcast)

1989

Biennial Exhibition of Contemporary Canadian Art,
National Gallery of Canada, Ottawa (with broadcast)

Selected Bibliography

Writings and Publications by the Artist

"Accompaniment to a Cinematographic Scene: Ruskin B.C."
West Coast Line, no. 26.2, Simon Fraser University,
Burnaby (Fall 1992), pp. 9–12.

"Introduction." In *Vancouver Anthology: The Institutional
Politics of Art*. Ed. Stan Douglas. Vancouver:
Talonbooks, 1991, pp. 304.

"Joanne Tod and the Final Girl." In *Joanne Tod*. Toronto:
The Power Plant, 1991, pp. 31–52. Reprinted in
Parachute, no. 65 (January–March 1991), pp. 11–17.

Link Fantasy. With Deanna Ferguson. Vancouver: Artspeak
Gallery, 1988.

"Police Daily Record." *Frieze*, no. 12 (September 1993),
pp. 46–47.

"Public Art in a Nutshell." Paper delivered at *The Politics
of Images*. Dia Center for the Arts, New York,
November 1990.

"Pursuit, Fear, Catastrophe: Ruskin B.C. (1993)." *Jahresring
41: Jahrbuch für moderne Kunst* (1994).

"Shades of Masochism: Samuel Beckett's Teleplays."
Photofile (Fall 1990), pp. 16–25.

"Television Talk." In *Art Recollection: Artists' Interviews and
Statements in the Nineties*. Ed. Gabriele Detterer. Danilo
Montanari and Exit and Zona Archives Edition, 1997.

"Television Talk." *Little Cockroach Press*, no. 1, Art
Metropole (April 1996).

Selected Interviews

"Broadcast Views." By Lynne Cooke. *Frieze*, no. 12
(September–October 1993), pp. 41–45.

"Le sonore et le visuel: Intersections musique/arts
plastiques aujourd'hui." By Jean-Yves Bosseur.
Dis Voir (1992), pp. 143–146.

Books and Catalogues

Samuel Beckett: Teleplays. Vancouver: Vancouver Art
Gallery, 1988. Texts by Samuel Beckett, Linda Ben-Zvi,
Clark Coolidge, and Stan Douglas.

Stan Douglas. Paris: Musée d'art moderne de la ville
de Paris, Centre Georges Pompidou, 1993.
Texts by Christine van Assche, Peter Culley,
and Jean-Christophe Royoux.

Stan Douglas. London: Institute of Contemporary Art, 1994.

Stan Douglas. Toronto: Art Gallery of York University, 1994.
Texts by Nancy Campbell and Catherine Crowston.

Stan Douglas. Montreal: Musée d'art contemporain, 1996.
Text by Gilles Godmer.

Stan Douglas. London: Phaidon Press, 1998. Texts by Carol
J. Clover, Stan Douglas, Diana Thater, and Scott Watson.

Stan Douglas. Vancouver: Vancouver Art Gallery, 1999.
Texts by Daina Augaitis, George Wagner, and
William Wood.

Stan Douglas: Evening and Hors-champs. Chicago: The
Renaissance Society of the University of Chicago, 1995.
Text by Hamsa Walker.

Stan Douglas: Monodramas and Loops. Vancouver:
UBC Fine Arts Gallery, 1992. Texts by John Fiske
and Scott Watson.

Stan Douglas: Overture y Monodramas. Caracas: Museo
Alejandro Otero, 1997. Texts by Jesus Funemayor,
Julieta Gonzáles, and Tahía Rivero.

Stan Douglas: Perspective '87. Toronto: Art Gallery of
Ontario, 1987. Text by Barbara Fischer.

Stan Douglas: Potsdamer Schrebergarten. Der Sandmann.
Krefeld: Museum Haus Lange and Museum Haus
Esters, 1996. Texts by Stan Douglas and Julian Heynen.

"Stan Douglas: Pursuit, Fear, Catastrophe: Ruskin B.C." In
Currents 24. Milwaukee: Milwaukee Art Museum,
1995. Texts by Stan Douglas and Dean Sobel.

*Stan Douglas: Television Spots/Subject to a Film: Marnie
(Studies)*. Vancouver: The Contemporary Art Gallery,
1988. Text by Miriam Nichols.

Production Credits

Win, Place, or Show, 1998
Two-channel video projection
four-channel soundtrack
204,023 variations with an average duration of six minutes each
Dimensions variable
Edition of two

Cast

Donald "Donny" Stenton
Barry Levy

Robert "Bob" MacKenzie
Peter Lacroix

Crew

Production Designer,
Director, Editor
Stan Douglas

Writers and Researchers
Stan Douglas
Peter Cummings

Cinematographer
Bob Aschmann

Associate Producer
Peter Cummings

Production Architect
Robert Kleyn

Stunt Coordinator
Charles Andre

Audio Post-Production
and Mix
Jennifer Lewis

Montage Programmer
Steve Dougall

1st Videographer
Doug Baird

Camera Operators
Glenn Taylor
Ted Cannem

Sound Recordist
Hans Fousek

Script Continuity
Debora Margolis

Gaffer
Anthony Metchie

Best Boy Electric
Kevin Short

Best Boy Grip
Ian Guns

Lamp Ops/Grips
Lance Rowley
Russell Lewis

Rigger
Mike Legree

Lighting Doubles
Johnathan Wells
Brian Jugen

Construction Coordinator
Derek Del Puppo

Carpenters
Greg Black
Robert Smith

Painter
Jürgen Gottschlag

Set Decorator
Tonya Soules

Assistant Set Decorator
Jeremy Stanbridge

Production Assistant
Ron Pachkowski

Hair/Make-up
Tina Tioli

Furnishings
Kitty Scott

Construction Consultant
Doug Hardwick

Catering
Edible Planet

Security
Larry Woodhouse

Foley
Boardwalk Foley

Foley Engineer
David Horner

Colorist
John Christie

On-Line Editor
Greg Vallieres

Matte Painting
Neil Wedman

Motion Effects
Image Engine

Sound Stage
Aja Tan Enterprises,
North Vancouver

Editing Facilities
Finalé Editworks,
Vancouver
Rainmaker, Vancouver

Audio Studio
Orca Pacific Sound,
Vancouver

Disc Mastering
Imation Optical Media

Thanks
Edible Planet; Abraham
Rogatnick; BC Archive &
Record Service; Murray
Gibson, The Characters;
Alexander Horvath; Martin
Walitza

Produced by
Stan Douglas
David Zwirner

Douglas Gordon

1966
Born in Glasgow
1984–1988
Glasgow School of Art
1988–1990
The Slade School of Art, London
1996
Awarded Turner Prize
Niedersachsiche Kunstpreis, Hannover
DAAD Stipendium, Berlin
1997
Awarded Premio 2000 at Venice Biennial
Central Kunstpreis, Kunstverein Cologne
1998
Hugo Boss Prize, Solomon R. Guggenheim Museum,
New York

Lives and works in Glasgow and New York

One-Person Exhibitions

2000
"Sheep and Goats," ARC, Musée d'art moderne
de la ville de Paris
1999
"Harmony," Moderna Museet, Stockholm
"Feature Film," Artangel Projects, London; Kunstverein
Cologne
Galerie Focksal, Warsaw
Gagosian Gallery, New York
"Double Vision: Stan Douglas and Douglas Gordon,"
Dia Center for the Arts, New York
Neue Nationalgalerie, Berlin
Centro Cultural Belém, Lisbon
1998
Kunstverein Hannover
"Kidnapping," Stedelijk Van Abbemuseum, Eindhoven
Dvir Gallery, Tel Aviv

1997
Galleri Nicolai Wallner, Copenhagen
Bloom Gallery, Amsterdam
Galerie Micheline Szwajcer, Antwerp
Galerie Mot & Van den Boogaard, Brussels
Gandy Gallery, Prague
"5 Years Drive-By: Overnight #1," Kunstverein Hannover
"Côté Rue," Galerie Yvon Lambert, Paris
"Leben nach dem Leben nach dem Leben . . . "
Deutsches Museum Bonn
1996
"24 Hour Psycho," Akademie der Bildenden Künste, Vienna
". . . head," Uppsala Konstmuseum, Uppsala
Galleria Bonomo, Rome
Canberra Contemporary Art Space
"Close Your Eyes," Museum für Gegenwartskunst, Zürich
Galerie Walchenturm, Zürich
"Raise the Dead," museum in progress, Vienna
1995
"Bad Faith," Künstlerhaus Stuttgart
"The End," Jack Tilton Gallery, New York
"Jukebox," The Agency, London
"Entr'acte 3: Douglas Gordon," Stedelijk Van Abbemuseum,
Eindhoven
"Fuzzy Logic," Centre Georges Pompidou, Paris
Rooseum Espresso, Malmö
1994
Lisson Gallery, London
1993
"24 Hour Psycho," Tramway, Glasgow; Kunstwerke, Berlin
"Migrateurs," ARC, Musée d'art moderne de la ville de Paris
1991
"London Road . . .," Orpheus Gallery, Belfast
1987
Transmission Gallery, Glasgow

Selected Group Exhibitions

1999

"Regarding Beauty: A View of the Late Twentieth Century,"
Hirshhorn Museum and Sculpture Garden,
Washington, D.C.

1998

"Wounds: Between Democracy and Redemption in
Contemporary Art," Moderna Museet, Stockholm
Hugo Boss Prize 1998, Guggenheim Museum Soho,
New York
Berlin Biennale, Berlin

1997

Sculpture.Projects in Münster 1997
XLVII Esposizione Internazionale d'Arte: "Passato,
Presente, Futuro," Biennale di Venezia
"l'autre," 4e Biennale d'art contemporain de Lyon, Musée
d'art contemporain

1996

Manifesta 1, Rotterdam
Turner Prize Exhibition 1996, Tate Gallery, London
"Scream and Scream Again: Film in Art," Museum of
Modern Art, Oxford
"Jurassic Technologies Revenant," 10th Biennale of Sydney,
Art Gallery of New South Wales

1995

"installation, cinéma, vidéo, informatique," 3e Biennale
d'art contemporain de Lyon, Musée d'art contemporain
Aperto '95, Biennale di Venezia
Kwangju Biennale

1994

"WATT," Witte de With and Kunsthal, Rotterdam

1993

"Viennese Story," Vienna Secession

1992

"Speaker Project," Institute for Contemporary Art, London
"Guilt by Association," Museum of Modern Art, Dublin

1991

Barclays Young Artists Award, Serpentine Gallery, London
"Bellgrove Station Billboard Project," Bellgrove, Glasgow

1990

"Self-Conscious State," Third Eye Centre, Glasgow

Bibliography

Writings and Publications by the Artist

"2 Days in Spring." In *On Board*. Venice: Riva San Biagio,
1995.

"A Bad Trip." In *Prospekt '93*. Frankfurt: Schirn Kunsthalle,
1993.

"Berlin Visit." In *Terminal*. Leipzig: Hauptbahnhof Leipzig,
1995.

"Colors for Identification . . ." *Frieze* 1, no. 2 (1992),
pp. 14–15. Collaboration with Simon Patterson.

Feature Film: A Book by Douglas Gordon. London: Artangel,
in association with Galerie du Jour—agnès b. (Paris)
and Kunstverein Cologne, 1999.

"Grim: Les Infos du Paradis." *Parkett*, no. 44 (1995),
pp. 197–201. Collaboration with Liam Gillick.

"In Love in Vienna." In *Viennese Story*. Vienna: Vienna
Secession, 1993.

"Lost, then found, then lost again. A True Story after
Samuel Beckett." *Witte de With Cahier*, no. 2
(June 1994), pp. 179–183.

The Missing Text. Ed. Marysia Lewandowska. London:
Chance Books, 1991.

"Paris Memories: Three-Minute Soundwork" (Audio). In
the exhibition "Before the Sound of the Beep." Paris:
Galerie Gilles Peyroulet, 1993.

"Point d'Ironie," no. 3 (November 1997). Commissioned
by agnès b. and Hans-Ulrich Obrist.

"Project." *Index*, no. 3–4 (Stockholm, 1995), pp. 54–63.

The Speaker Project (Audio). London: Institute for
Contemporary Art, 1993.

"Textwork." In *itinerant texts*. London: Book Works, 1995.

"Wall Drawing." In *Wall To Wall*. Leeds: Leeds City Art
Gallery, 1995.

Books and Catalogues

Entr'acte 3: Douglas Gordon. Eindhoven: Stedelijk Van
 Abbemuseum, 1995. Text by Selma Klein Essink.
Fuzzy Logic. Paris: Centre Georges Pompidou, 1995.
 Texts by Christine van Assche and Pierre Leguillon.
Douglas Gordon. Hannover: Kunstverein, 1998. Texts by
 Lynne Cooke, Charles Esche, Friedrich Meschede, and
 Eckhard Schneider.
Douglas Gordon. Lisbon: Centro Cultural de Bélem, 1999.
 Texts by Christine van Assche, Raymond Bellour,
 Pavel Büchler, Jeremy Millar, and an interview by
 Oscar van Boogaard.
Douglas Gordon: 24 Hour Psycho. Glasgow: Tramway
 Gallery, 1993. Text by Stuart Morgan.
Douglas Gordon: Close Your Eyes. Zürich: Museum für
 Gegenwartskunst, 1997. Texts by Rein Wolfs and
 Francis McKee.

Douglas Gordon: Déja-vu, Interviews 1992–1999. 3 vols.
 Paris: Musée d'art moderne de la ville de Paris, 2000.
 Texts by Harald Fricke and Elisabeth Lebovici.
Douglas Gordon: Kidnapping. Eindhoven: Stedelijk Van
 Abbemuseum, 1998. Texts by Thomas Lawson and
 Russell Ferguson, David Gordon, and Douglas Gordon,
 and a conversation with Jan Debbaut.
Migrateurs. Paris: Les Amis du Musée d'art moderne
 de la ville de Paris, 1993.
Parkett, no. 49 (May 1997). Special edition Douglas
 Gordon. Texts by Tobia Bezzola, Russell Ferguson,
 Richard Flood, and Douglas Gordon and Liam Gillick,
 pp. 36–83.
The Sociable Art of Douglas Gordon. Glasgow: Tramway
 Gallery, 1993. Text by Ross Sinclair.

Production Credits

left is right and right is wrong and left is wrong and right is right (1999)
video installation
97 minutes

Douglas Gordon wishes to thank the following people and organizations
for their help in realizing this work:

David Archiebald
Barry Barker
Barbara Clausen
Lynne Cooke
Steve Dougall
Steven Evans
Larry Gagosian
Kay Pallister
Bert Ross
Jim Scheaufele
The Edit Suite
Gagosian Gallery
Lisson Gallery